THE UNFOLD PROJECT

FOUNDED BY:
AMANDA HALLESJO

FOLLOW US ON SOCIAL MEDIA
@THEUNFOLDPROJECT

Author's note

Did you know that most people think self-love is selfish?
Well, it isn't.
It is our innermost need.

When we accept ourselves fully, we can give to others of our time, our energy, and our love.
Personally, I have a tendency to spend a lot of my time taking care of others, filling my time with distractions so I don't need to focus on myself.
I have spent so many hours, days and years being in war with myself and the only thing that finally allowed me to slowly get out of that pattern were gratitude practice.

That is why I started The Unfold Project.
I want more people, currently women, to stop searching for approval and acceptance in external things. I want people to find that approval and acceptance within.

I encourage you to write down what you love about yourself and answer the questions on every page. Even if it takes a lot of work — do it.
You're unique and special in your own way.
We all are.

Acknowledgements

Angela Prado
—

She took me in as an intern after I graduated college and am not only my boss, but also a lifelong friend.
I wouldn't start this project if it wasn't for her.

Jessica Collins
—

My amazing teacher I had my senior spring in college.
Her guidance and feedback have been invaluable.

Kelley Flint
—

For simply letting me use her computer to create this book when I didn't have the Adobe Creative Suits on my own.

Annika Hallesjo
—

My mother.
She is the most kind-hearted woman I know, and she has been so unbelievably encouraging regarding this project.
She gave me courage to just go for it and to finish something she knew I was passionate about.

—

Also a huge thank you to everyone who unfolded their inner beauty in this book. I hope you understand that you will touch so many hearts out there with your words.
You are an inspiration.

Voices about The Unfold Project

"I'm so glad I found this platform. I really only found it when I was looking up some coffee places in RVA. I think what you're doing is amazingly beautiful. Thank you for making my day."

"So much beauty in what you're doing."

"Your project is incredible and helps me keep my head up on bad days."

"I've been wanting to send you my submission for a while now but I honestly haven't thought before what I love about myself and why I love myself. I know my strengths per se, which is why I think this movement is awesome."

"My only feedback is to keep going. You're making a difference."

"Just wanted to say that this project is incredible, inspirational and so freaking cool. It makes me happy to read about other women and allows me to have more courage to unfold my own beauty."

"I think it's amazing you were able to create a space where people have felt comfortable sharing their self-reflection. I'm not one to usually tell others how I see myself or feel, but reading all of the stories have really helped. Not to mention, talking about your project serves as a gateway into a much-needed conversation. I just had a long chat with my roommates about our strengths and how we viewed ourselves. It was super uplifting. Thank you for all of this."

Read it, be inspired, reflect, and then unfold your inner beauty.

Being a woman... that is brave in itself.
Making tough choices to live in my truth.
Listening to the voice inside me and tuning out that which does not serve me.
Always willing to shift my perspective for the purpose of growth. I love my capacity to love and connect with people.

I love that I can be spontaneous and feel when I'm stuck.
I love my cackle laugh and my appetite for always wanting to learn and discover more about the world and the people around me.

I love that I wear my heart on my sleeve.

When was the last time I told myself "I am enough"?

Life is too beautiful to let anything get in the way of my happiness and well-being.
I am in control of my emotions.
I am brave.
I am brave because I live with depression and anxiety.
I refuse to let it impact my life.
The scary strike of anxiety, I silence it right away.

The tears that fill in my eyes when I think about the tragedy are immediately dried
when I remind myself that I have so many wonderful people in my life and that my future is bright.

WHO ARE YOU BECOMING AND WHAT ARE YOU MOST GRATEFUL FOR?

I love that I can find strength in being vulnerable;
that I create my lasting connections with people through empathy and compassion.
I love that I show I care through quiet actions and that I am a safe shoulder to cry on.
I love that I see beauty in the ordinary things around me, being a simultaneous daydreamer and stargazer.

I love my romantic soul.

WHAT ARE YOU MOST EXCITED ABOUT NOW AND HOW CAN YOU EXPERIENCE MORE OF THAT?

I love that I radiate positive energy and make people around me happy.
I love that I believe in myself both mentally and physically and can get through any challenges in life.

What am I running from?

I love that no matter what
I always forgive people and no matter what happens I
will be there for them till the end.
It makes me feel happier inside to always love everyone
and to be the one that people know they can always go
to.

Have I explored life outside of my comfort-zone?

I love that I can listen to other people's opinions
and value them, even if I don't agree.
To discuss with someone with a completely different
point of view than my own makes me stronger.
I collect opinions, arguments and values and I
love that all of it adds up to who I am today.
I love meeting new people, to gain but also provide
knowledge about the world.

I love that I am such an openminded person.

WHAT COULD I START DOING, OR STOP DOING, TO DEEPEN MY RELATIONSHIP WITH MYSELF?

I have recently discovered I love my wild side.
I love that I make a decision in a split second.
I love that I am too much for some people.
I love that I keep people on their toes,
and I love that I don't ever have a plan.
I love that I can fall straight on my face,
but can pull myself up and find the humor in it.

Make a list of everything you'd like to say yes to:

I love that I'm a reflecting person who always strive to understand myself and others. What makes me strong is that I never give up no matter what.

I'm brave because I face my fears and try to do the things that scares me the most instead of avoiding it.

WHAT DID I PROMISE MYSELF I WOULD DO BUT I CAN NOW RELEASE?

What I love about myself is my quality to light up a room or bring people happiness.
I go out of my way to always make everyone happy, even at the expense of my own happiness sometimes.

While a lot of people criticize this quality calling me weak or a pushover,
I find myself to be someone that can love and be loved by all.
This actually makes me strong because no matter what I am going through,
I find a way to project positivity and radiate a genuine smile because I can always find something to be happy about and love spreading smiles to everyone around me.

Even when I am upset,
I find a way to make light of all situations and still make people happy no matter what I am going through.
I find myself to be brave by not letting things get me down and continuing to spread my happiness and smile to all, especially when most people wouldn't be able to if they were in my shoes.

IS THERE SOMETHING I AM CALLED TO DO BUT I THOUGHT WOULD BE IMPOSSIBLE?

I love my ability to connect with people.
I love that I enjoy talking to the 8-year olds I
babysit as much as I love to talk
to my grandparents who are in their 70s.
People fascinate me regardless of where they come from.

I am brave because I was able to take a chance on
something I never thought I would be able to do.
Coming to college to play a Division I sport was
something I only dreamed of doing
and I was finally able to take a chance and leave my
comfort zone.
In my three years at college, I was able to better
myself and grow into a strong woman.

Make a list of 30 things that make you smile:

I love how strong I've built myself and my discipline.

I'm brave because I'm not afraid to be confident and make myself a priority.

I REALLY WISH OTHERS KNEW THIS ABOUT ME...

I LOVE THE PATIENCE I HAVE WITH MYSELF AND WHENEVER I AM GOING THROUGH DIFFICULTIES. I ALWAYS REALIZE HOW STRONG I AM.

WRITE ABOUT A MOMENT EXPERIENCED THROUGH YOUR BODY:

I love my hopeful and curious attitude that I know I can always rely on when things may seem uncertain or bleak.
I am unique because I naturally love to create networks of connections and love to provide resources for others to be the best they can be.

I love to think from an innovative mindset.

WHAT DO YOU NEED TO BE MORE AT PEACE WITH YOURSELF?

I love that I can be happy spending time alone with just my thoughts.
But I also love that I'm challenging myself to spend time outside of my introverted comfort-zone and have new experiences.

WHAT DO I MOST LOVE ABOUT MYSELF AND HOW AM I SHOWING THAT TO THE WORLD EVERY DAY?

I love that I can set goals and stick to them and that I am a good motivator.
I love that I am a source of comfort for many people in my life and that I can make people laugh easily.
I love that I am comfortable around any kinds of people, that I am surrounded by amazing people — my husband, my son, my parents, my best friends.
I love that I have done a great job with my son Zander — even though he did most of it on his own.
I love that I am openminded and not phased by people that aren't like I am.

I am a strong woman because I have changed my life by losing 80 pounds and working out to get strong, not just skinny.
I am strong and brave because I ran a marathon 2 years ago after tireless training. And that I was the first person in my family to go to college and then went onto get my masters.

SOMETHING THAT MAKES ME UNIQUE IS...

I'm sure a lot of girls won't talk about a physical trait.
I adore my hazel eyes and how expressive I can make them. I didn't really notice until I participated in a UX project at the Brandcenter called IrisCam.
My eye was on twitter for the world to see.
My aunt commented on the facebook photo:
"I didn't know you have green eyes!"
I was contemplating if I had hazel or green eyes.
– I never had thought that much about them.
Now I show them off whenever I can.
I look at them in the mirror, and they remind me how beautiful I am inside to appreciate a small characteristic.

Name a compassionate way you've supported a friend recently.
Then write down how you can do the same for yourself.

I AM STRONG BECAUSE I HAVE LEARNT TO LOVE MYSELF.
IF YOU LOVE YOURSELF, YOU CAN GET ANYONE TO LOVE YOURSELF.
BECAUSE THERE' NOTHING AS HARD AS LOVING YOURSELF.

USING 10 WORDS, DESCRIBE YOURSELF:

What I love about myself is how I have overcome my performance anxiety.
I could wake up every day an hour before my alarm went off with anxiety and the feeling of not doing enough or being enough.
I thought that I needed to know everything and do everything perfectly. But today I know that no one can do everything perfectly, perfect doesn't exist.
All I can do is to try my best and that my job is just a job, not my whole life.

How can you love yourself more today?

I love that I have compassion for everyone and the ability to put myself in their shoes.

I love that I choose to understand.
I love that I keep my word when people tell me things.
I love that I get joy from helping others.

WHAT IS YOUR "WHY"?

If I had to pick one word, it would be my resilience. I love how I have proven time and time again how strong I am.

As a woman living with multiple chronic illnesses, it's easy to feel weak and easy to get defeated.
But being able to wake up every day and get my shit done with a smile on my face seems pretty strong to me.

WHAT IS YOUR TRUTH
WHEN EVERYTHING ELSE
IS STRIPPED AWAY?

I AM STRONG BECAUSE I CAN TURN MY WEAKNESSES INTO MY STRENGTHS, BECAUSE I HAVE PUT A LOT OF FOCUS ON WORKING ON THE THINGS I THOUGHT FELT HARD.
I AM STRONG BECAUSE I HAVE THE POWER TO LIVE WITH A LOT OF ANXIETY, I AM STRONG BECAUSE DESPITE MY ANXIETY I CAN TURN A BAD DAY INTO ONE OF THE BETTER ONES.

What always brings tears to your eyes?

What I love about myself is my strength.
I have become such a strong woman because of the relationships I've been in, the people that told me I couldn't and the injuries that took place in my life.
I learned through them and I learned how relentless I was through these experiences.
It's truly humbling to see how far I'll continue to grow.

My goal is to help young women grow through my stories to show them that there will be a light at the end of the tunnel.
I can't wait to stand in that light someday.

To give someone the push they need to get where they want to be.

What drives you?

I love that I am loud and outspoken and that I am true to myself.
I love that people feel like they can talk to me about their feelings and come to me for comfort.
I love that I will give them an honest answer back.
I love that I see beauty in life and try to see it in every situation.
I love that I am strong enough to get passed, move on, and forgive in any situation that has happened to me.
I love that I am always trying to be a better version of myself.

Things that make me beautiful:

What I love about myself is my resiliency and tenacity to be myself and love myself.
It can be hard work but its work worth doing.
What makes me brave is accepting myself, flaws and all.

I FEEL MOST ENERGIZED WHEN...

I LOVE THAT I ALWAYS TRY TO BE A KIND AND ACCEPTING PERSON, NO MATTER THE CIRCUMSTANCES.
THAT I CONSTANTLY WORK ON CHALLENGING MYSELF TO BECOME A MORE WELL-ROUNDED AND APPRECIATIVE HUMAN BEING, TOWARDS OTHERS AND TOWARDS MYSELF.

I APPRECIATE MY WAYS OF FACING ADVERSITY, WHERE I ALWAYS STRIVE TO SEEK OPPORTUNITIES AND GROWTH, EVEN DURING THE HARDER TIMES IN LIFE.

MAKE A LIST OF EVERYTHING THAT INSPIRES YOU:

I love that I am not afraid of my depths or of my demons.
I love that I accept multiple and dynamic truths about myself, without losing love for myself.
I love my indomitable spirit.
I love that I believe in working hard.
I love that I am my own source of energy.
I love where I come from:
a long line of Irish and French immigrants who were soldiers, card sharks, bridge builders, and miners.

I am a brave woman because I choose me.
I am a brave woman because I choose love.
I am a brave woman because I choose progress over perfection.

WHAT DO I WANT TO BE KNOWN FOR?

I had to endure bullying about my weight and weirdness from 3rd grade on.
I was a weird kid but who wasn't?
I still have self-esteem issues.
I'm brave enough to say screw them.
I'm my own person and if someone doesn't like me that's on them. They don't know the hours I spent in practice rooms practicing clarinet solos. They don't know how hard I've worked to get to where I am today.
I'm a boss ass bitch so deal with it y'all.

WHAT WORRIES ME MOST ABOUT THE FUTURE?

I love that I make people laugh.
Life shouldn't be so serious, and I think it's important that we try to find comic relief in it from time to time.
I am brave because I am not afraid of embracing the suck.
Sometimes life doesn't hand me lemons, instead I'll get oranges.

And guess what?
It will be the best damn OJ with no pulp.

WHAT DO YOU VALUE ABOUT YOURSELF?

I love that I still have the capacity to dream big.
I love that I'm finally pursuing my life's passion, instead of what I thought society needed me to be.
I love that I'm finally confident in my own weaknesses and the realization that they challenge me to be a stronger, better, and more confident person on a daily basis.

WHAT DOES SELF-LOVE MEAN TO YOU?

I LOVE THAT I'M CONFIDENT.
AND WITH THAT CONFIDENCE I CAN GO OUT INTO THE WORLD
AND BE A BOOS ASS BITCH.

What does unconditional love look like for you?

Recently I have found struggle with looking within myself and seeing beautiful and positive characteristics. Maybe that is just that, though.
I am not content with being an average student, athlete, friend and daughter.
Although I am not exactly where I want to be right now, at least I have the strength and self-awareness to know that I can do better, be better and will work tirelessly until I get myself there.

I FEEL HAPPIEST IN MY SKIN WHEN...

I love that I never hide from my emotions.
I am brave because I allow myself to feel, love and live intensely.
I am proud of myself for finally admitting that I have an unhealthy relationship to food.
That I am living with a skewed body image.
It has taken a lot of energy and nearly 15 years to admit to it.
But ever since I did, I've found myself stronger and happier even though the problem still remains.

I love that I have a kind heart.
I love that i am a social butterfly and connect with people everywhere I go.

But the one thing I love the most about myself –
is my enthusiasm for life.
I love that no matter where life takes me, you'll most likely always find me with a smile.

WHAT DO YOU DARE TO DREAM OF DOING? WHAT DO YOU LONG TO EXPERIENCE OR CREATE?

I love my personality!
I love the way that I can bring a smile to someone's face by telling a story or making a joke.
It's a warming feeling knowing that I can change someone's emotion and bring them some light.

I love the fact that I can get through whatever trouble I'm facing.
I take what the world gives me and turn it into a learning experience.
I don't take no for an answer. I work hard for what I want.
My resilience and ability to realize that the sky is the limit make me unstoppable.

TO STEP INTO YOUR TRUE POTENTIAL, WHAT MUST YOU LEAVE BEHIND?

I love that I am a generous person who cares a lot about the ones around me.
I lost my husband to cancer 9 years ago, and I am a strong woman because I have been fighting to be content with being alone ever since.
I am a strong woman because I have realized how important it has been to love yourself when life happens.

WHAT AM I HOLDING ONTO THAT ISN'T SERVING ME ANYMORE?

I INSPIRE TO ONE DAY FEEL COMPLETELY CONFIDENT AND HAPPY WITH MYSELF. I STRIVE FOR SELF-LOVE, ONE DAY AT A TIME.

DOES IT REALLY MATTER WHAT OTHERS THINK ABOUT ME?

I love the fact that I am able to give a lot to people: emotions, help and feelings.
Facing life every day with a smile, even if I know it can be really hard and unpredictable and that everything can end in a second.

Feeling among all that life is beautiful and having the strength and the faith to believe in it every day.

AM I WHO I WANT TO BE?

The thing I love about myself as a woman is knowing with heart knowledge that there's an unbreakable bond of strength in this shared sisterhood.
I see it reflected in my daughter's eyes or when I glance at my own hands and recognize them as my mothers.

Loving ferociously, giving life, living boldly.
Strength in sacrifice.
Strength in giving.
There is really nothing on this planet stronger than a woman.
I love that I am a small part of this beautiful sisterhood.

HOW DOES IT BENEFIT ME TO HOLD ON TO THESE FEELINGS I AM FEELING RIGHT NOW?

I love that I am becoming braver as I get older. Some things I do nowadays I wouldn't imagine doing a couple of years ago. I have more courage to go out and meet new people and to be myself to the fullest. When I was fifteen, I was hiding my uniqueness but today I am embracing them.

How would you describe yourself?

I love that I always see the best in people.
I am a caring person, and I am very nice. Some people may call it being naive, but I rather live with a positive outlook on life than having a negative one.

I love that I don't give a shit about what society think a woman should look, behave and act like.
I am strong and I love that my body manage to do everything it does. I would never let myself become weaker just to follow a norm or ideal of how a woman should be, for example that a woman shouldn't have toned muscles.

How can I surround myself with people who encourage me?

I LOVE THAT I'M EXTREMELY LOYAL TO MY FRIENDS AND THAT I ALWAYS STAND UP FOR WHAT'S RIGHT, EVEN IF IT MIGHT GET ME IN TROUBLE OR STAND ALONE.

What Am I Prepared To Leave Behind?

Something I admire about myself is my relentless ability to love. I used to think continuing to give humanity the benefit of the doubt might only leave me disappointed or hurt.
But now I realize in a world so viciously attempting to turn warm hearts to stone,
my ability to love regardless is my greatest gift.

What do I need most right now?

I love that I'm open-minded and enjoy diversity in everything. I'm brave because I'm always me and I always stand for what I believe in even if I stand alone.

What Is Stopping Me From Having It Now?

A lot of people may disagree, but I love my fear of failure. It is what drives my success in anything I do and keep me on my toes.
I am brave because I know what I am capable of and am not afraid to talk about it.

What are the most important things to you in life?

I love that I am stronger than what I think.
Every time I face a difficult situation I can survive and move on better than expected.

What are the biggest things you've learned in life so far?

I used to think I was a strong woman because I was independent and didn't need anyone. Now, I think I'm strong because I was able to let down that wall and have someone by my side. That's what I love about myself too. I was able to overcome all those fears and learned to let someone support and care for me. I understood that the key to happiness is not about reaching goals and being successful, but being able to share your life with someone you love with all your life. That's what I love about myself the most.

What toxic thoughts and behaviors do I need to get rid off?

I love that I try to better myself every single day. I wake up with the intent to be the best version of myself, regardless of what other people are doing.

I'm brave because I hold myself to a high standard, but give myself grace when I fail.

Are you settling for less than what you are worth? ... Why?

I asked my mom what she loves about herself and what makes her a strong woman, because I have always thought of her as the strongest woman I know. She raised my sister and I on her own and never gave herself the credit she deserved. Often times, she talks down on herself as a parent and it breaks my heart because she is my entire world.

Having the conversation with her about what makes us strong was really powerful because she said what makes her strong was that she is independent and she knows she can stand on her own.

How do you love yourself enough to consistently expand your mind?

What makes me strong is that I am able to carry myself and keep chasing after my dreams, but I have the self-realization to know when I need help and I am not afraid to ask for it. I think there is beauty in the duality of independence/freedom and companionship. My mom raised me to be comfortable on my own, but she has always been my support system and caught me whenever I fell. The strong women in my life make me strong.

My favorite personality trait about myself is...

I THINK WHAT MAKES ME A STRONG WOMAN IS SURROUNDING MYSELF WITH THOSE WHO MOTIVATE ME AND RAISE ME UP. ALSO, THE FACT THAT I'VE FOUND CONFIDENCE AND HAVE DILIGENCE IN THE THINGS I DO ALSO PAYS A BIG ROLE IN ME FEELING STRONG. I RUN AFTER THE THINGS THAT I AM CURIOUS ABOUT. I KIND OF ENJOYING THE UNCOMFORTABLE. I DON'T KNOW, THERE ARE SO MANY REASONS TO LOVE OURSELVES.

I AM EMOTIONALLY STRONG WHEN...

I love that people feel like they can trust me with their deepest secrets. I'm always down to give advice to my friends, or really anyone who needs it. Even though I may not have experienced what they're going through, people still come to me with their problems and it makes me feel valued as a friend. I think me being able to empathize with people makes me a strong because it takes a lot to deal with one's own emotions let alone someone's else.
I've never thought of my emotions as burdens, but more of an inspiration.
This may not make sense, but seeing the strongest people I know go through situations makes me realize there's more to life than a bad day or a shitty text from an old friend. I consider myself a strong woman because I'm able to put my own problems aside to help the people that mean the most to me.

What can you do to be more comfortable talking to people you don't know?

I love that I am optimistic. I love that I see the best in people. I don't suspect or judge them. I look for the good instead.

I love my looks. I actually think I am quite pretty. I would never have said this when I was 15, but here I am 40 years later and really like how I look.

Are you afraid of letting others get close to you? ... Why?

After answering all these questions and being inspired by quotes from the women who participated in this project,

I now want you to answer the two questions this project is based on

1. What do you love about yourself?

2. What makes you a strong woman?

www.ingramcontent.com/pod-product-compliance
Lightning Source LLC
Chambersburg PA
CBHW020544220526
45463CB00006B/2181